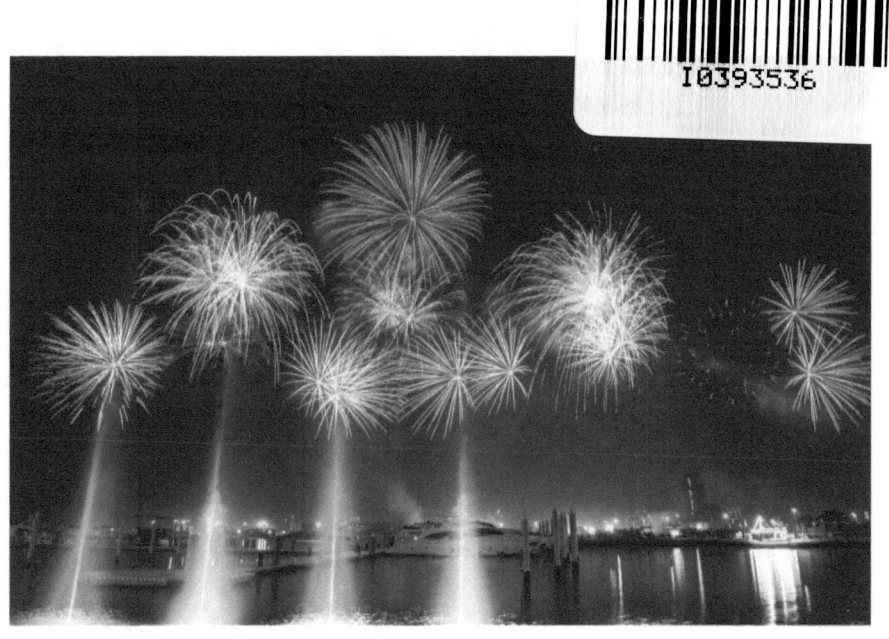

Dubai emerged as a global city and business hub of the Middle East. It is also a major transport hub for passengers and cargo. By the 1960s, Dubai's economy was based on revenues from trade and, to a smaller extent, oil exploration concessions, but oil was not discovered until 1966. Oil revenue first started to flow in 1969. Dubai's oil revenue helped accelerate the early development of the city, but its reserves are limited and production levels are low: today, less than 5% of the emirate's revenue comes from oil

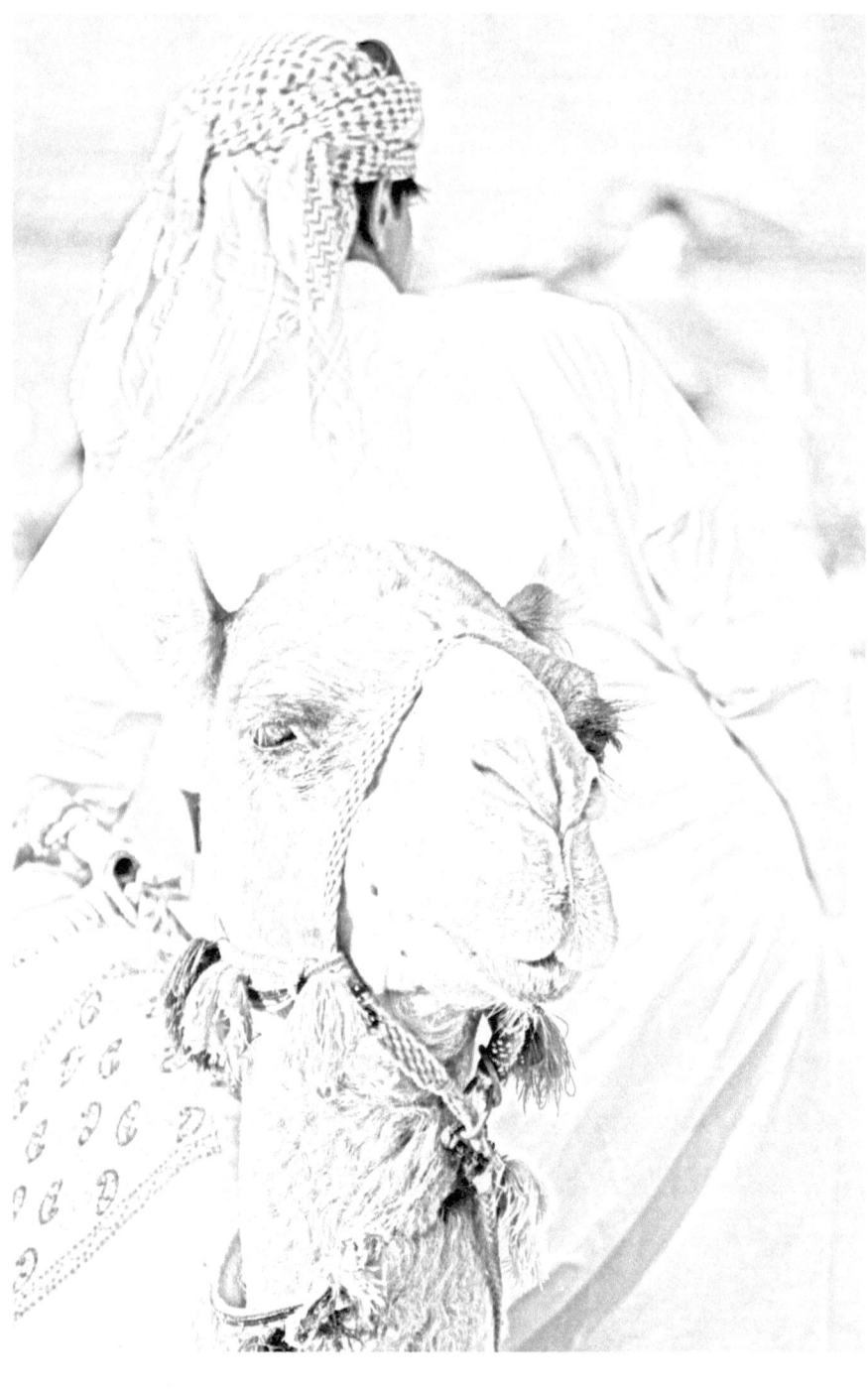

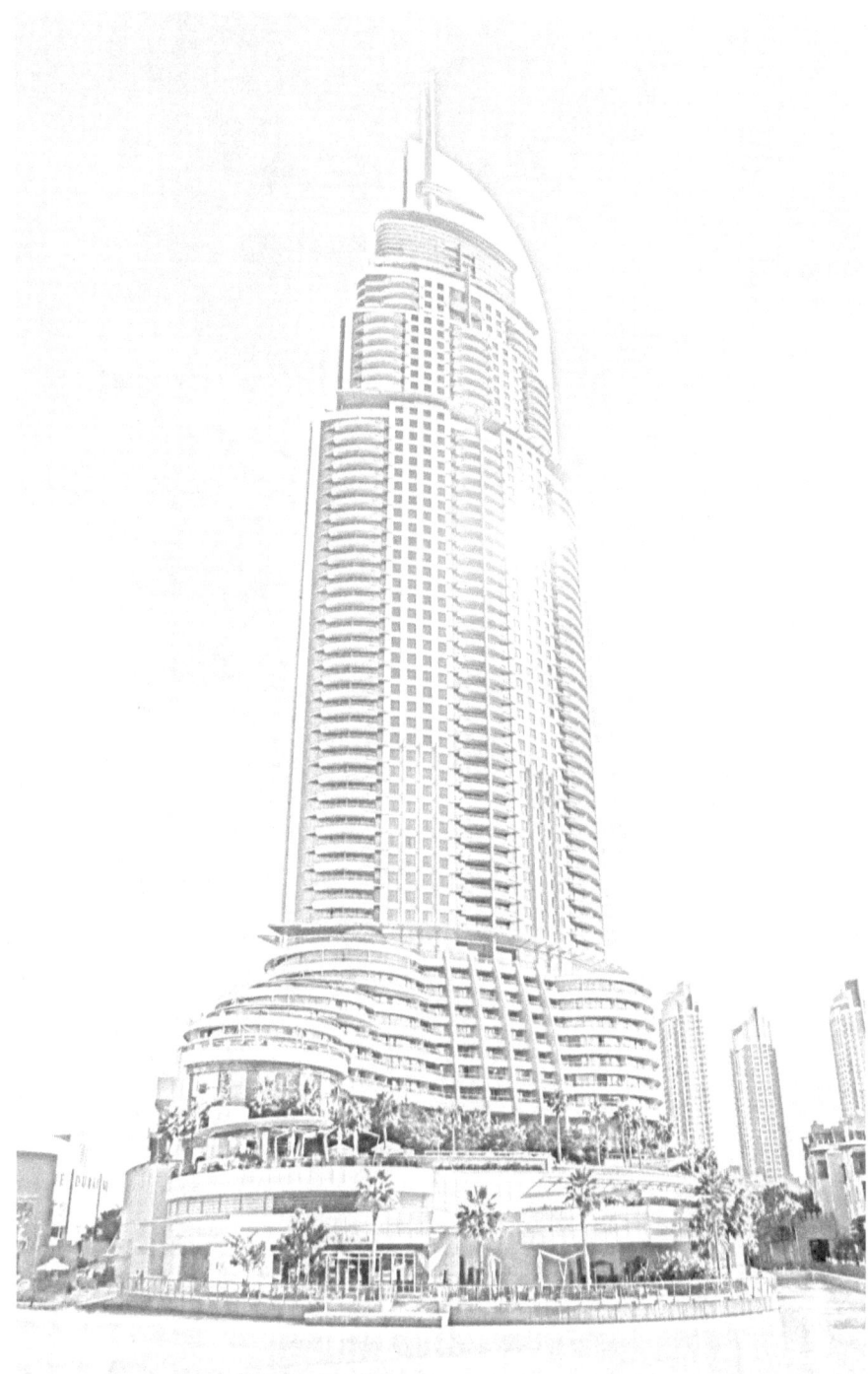

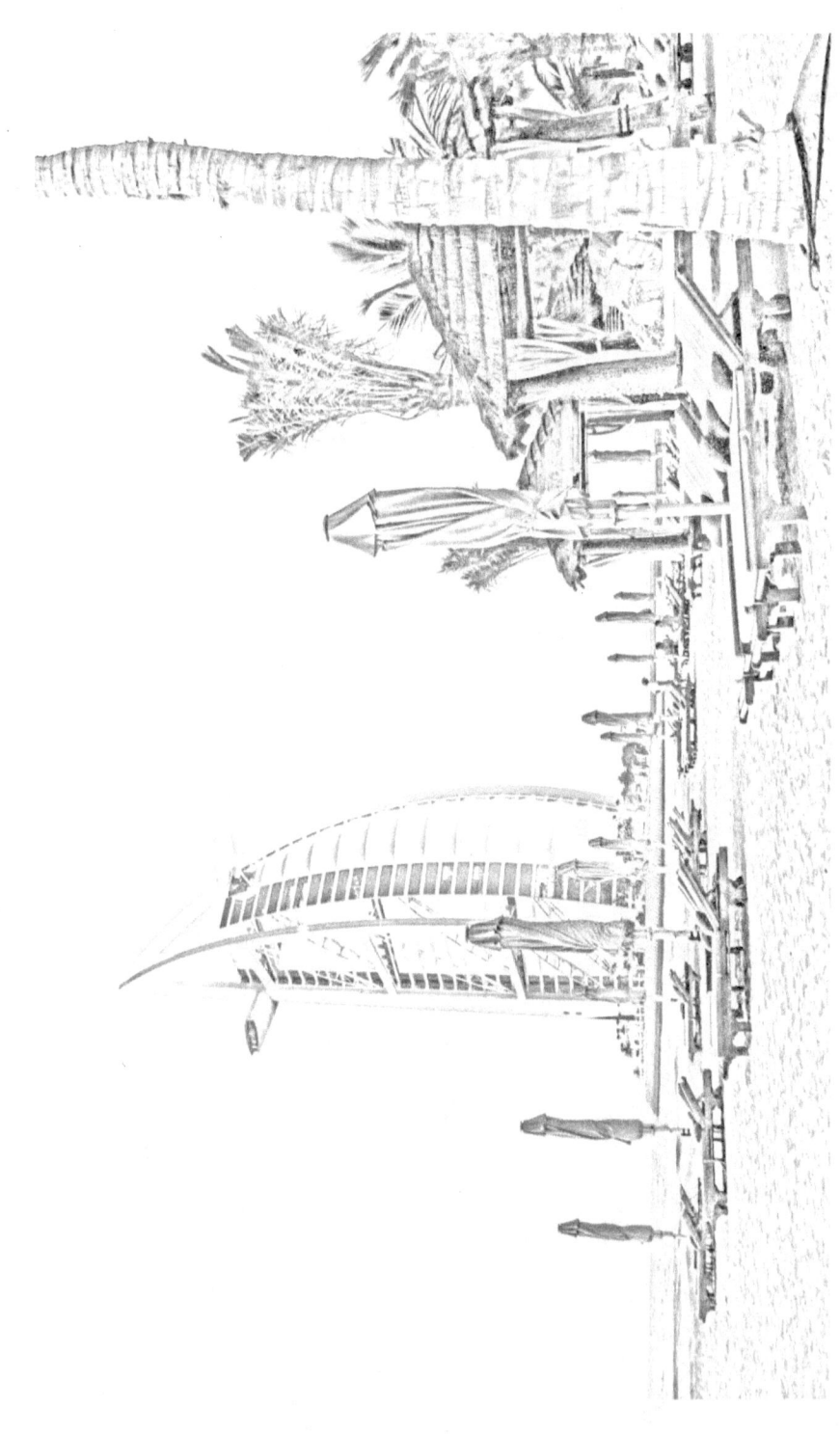

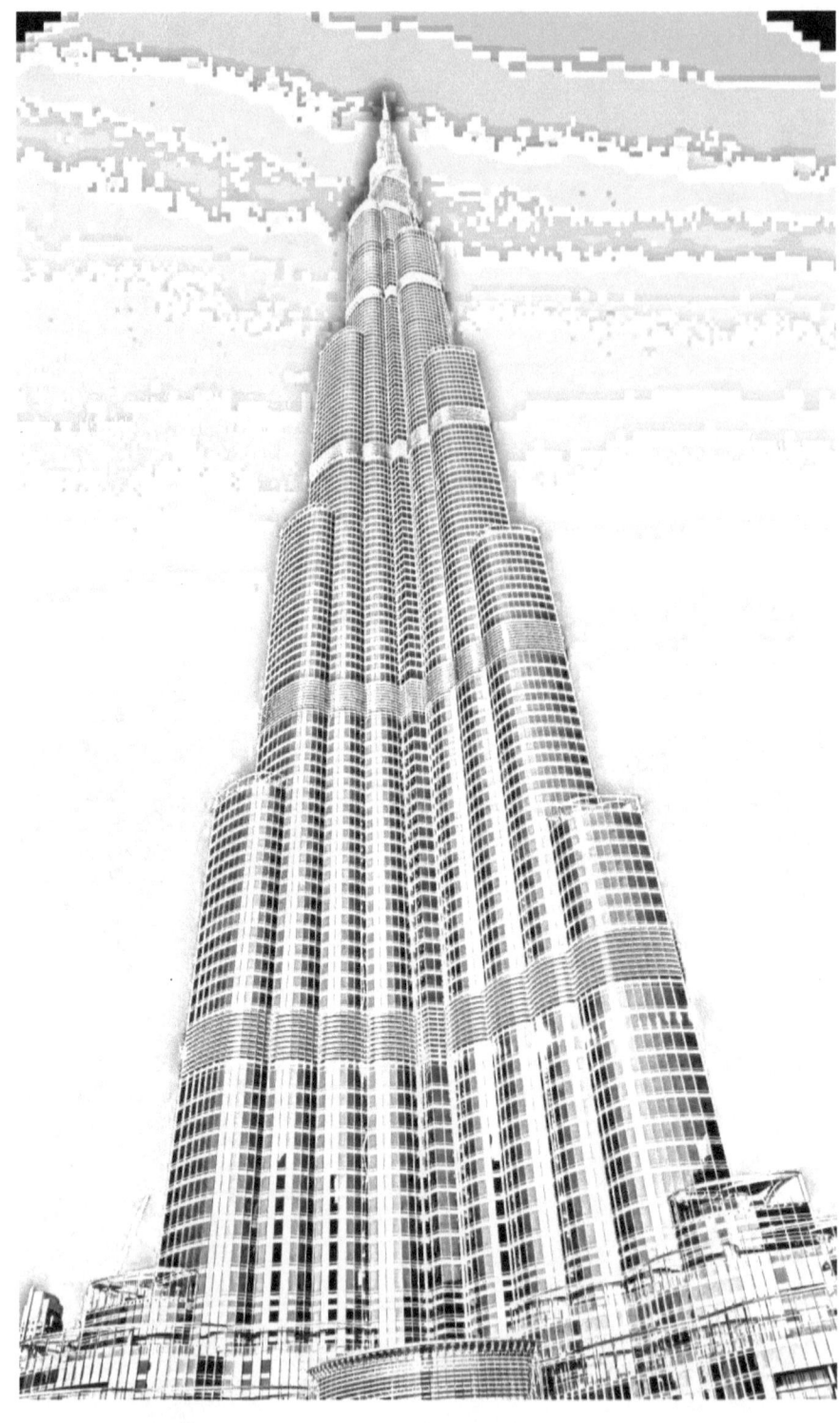

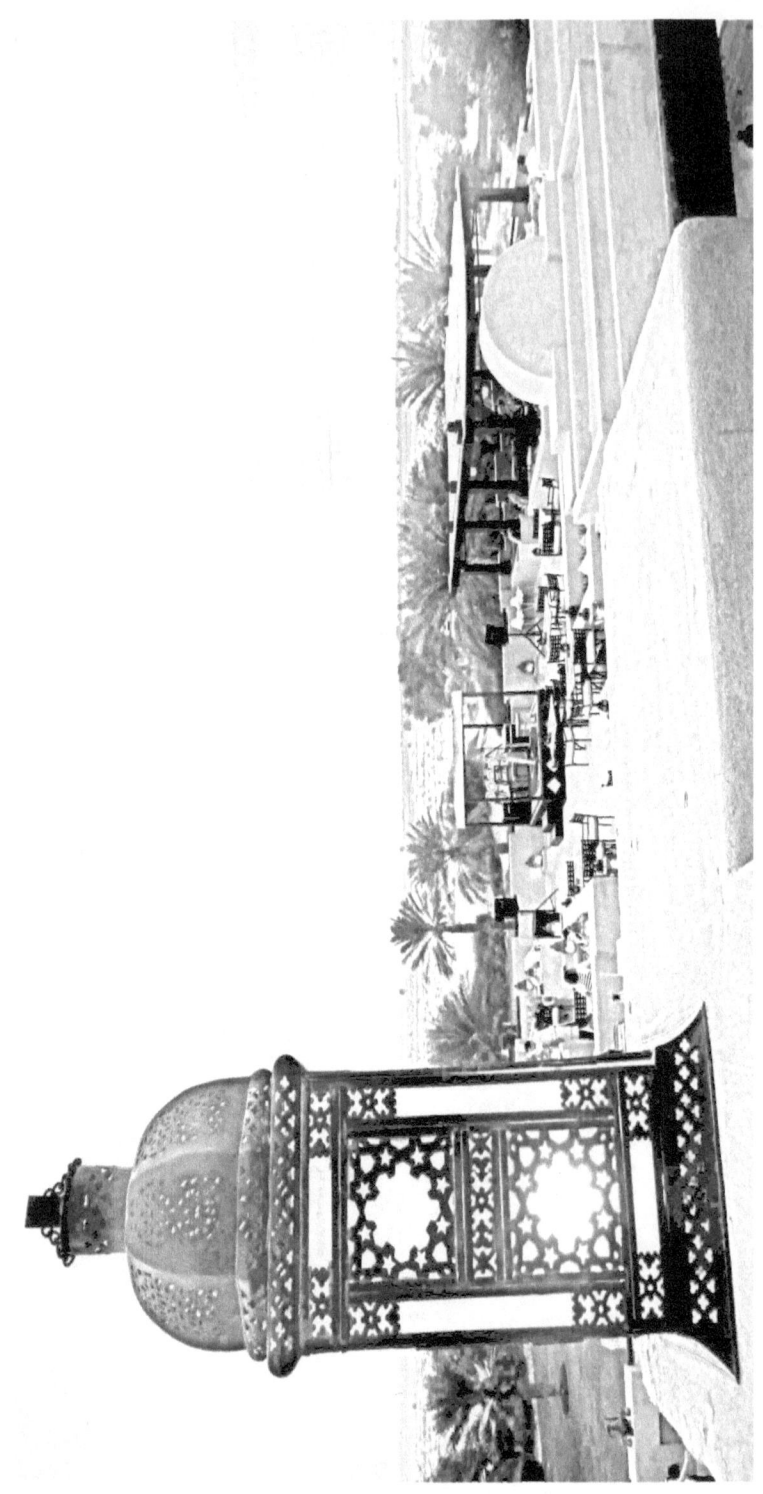

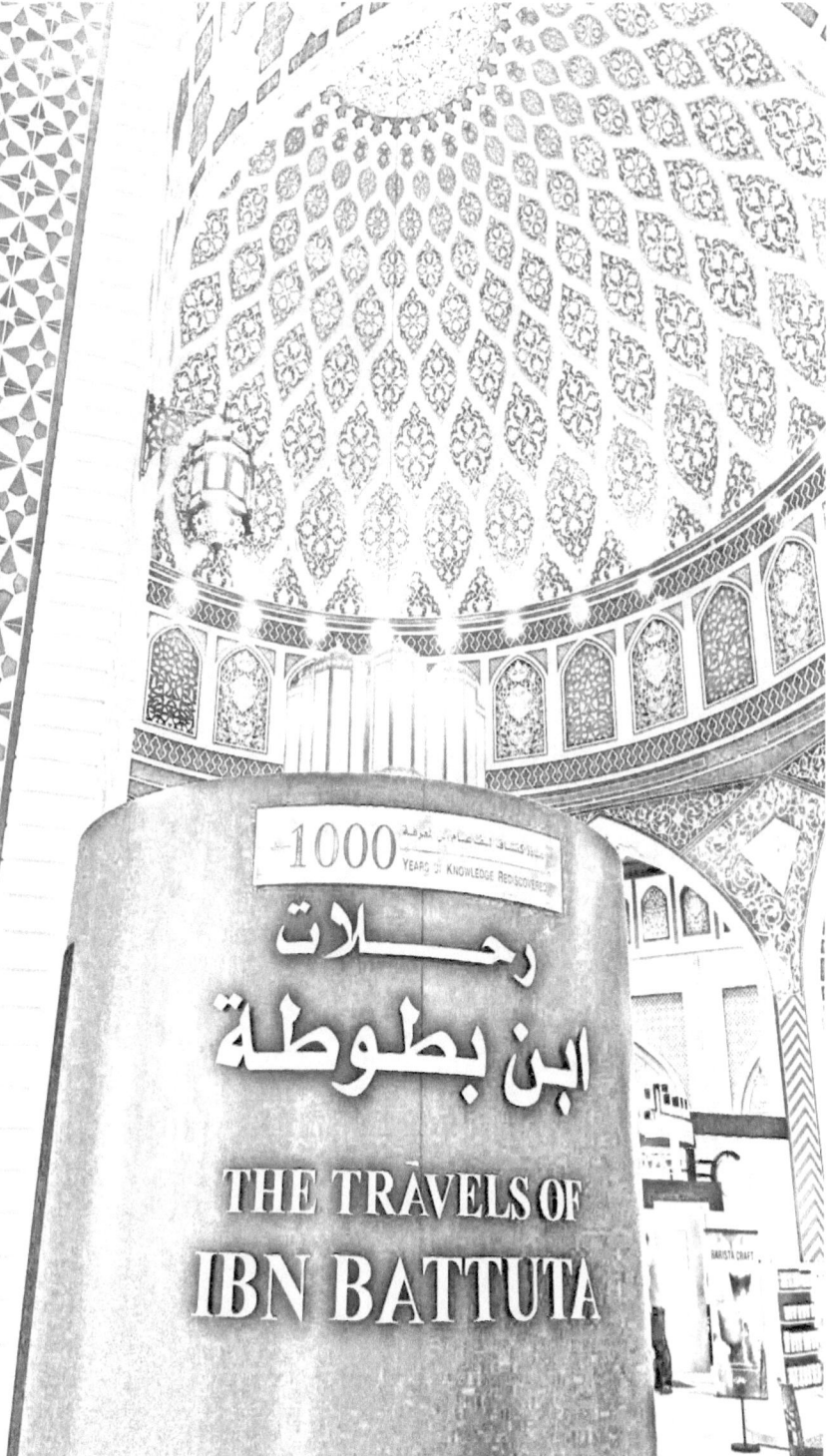

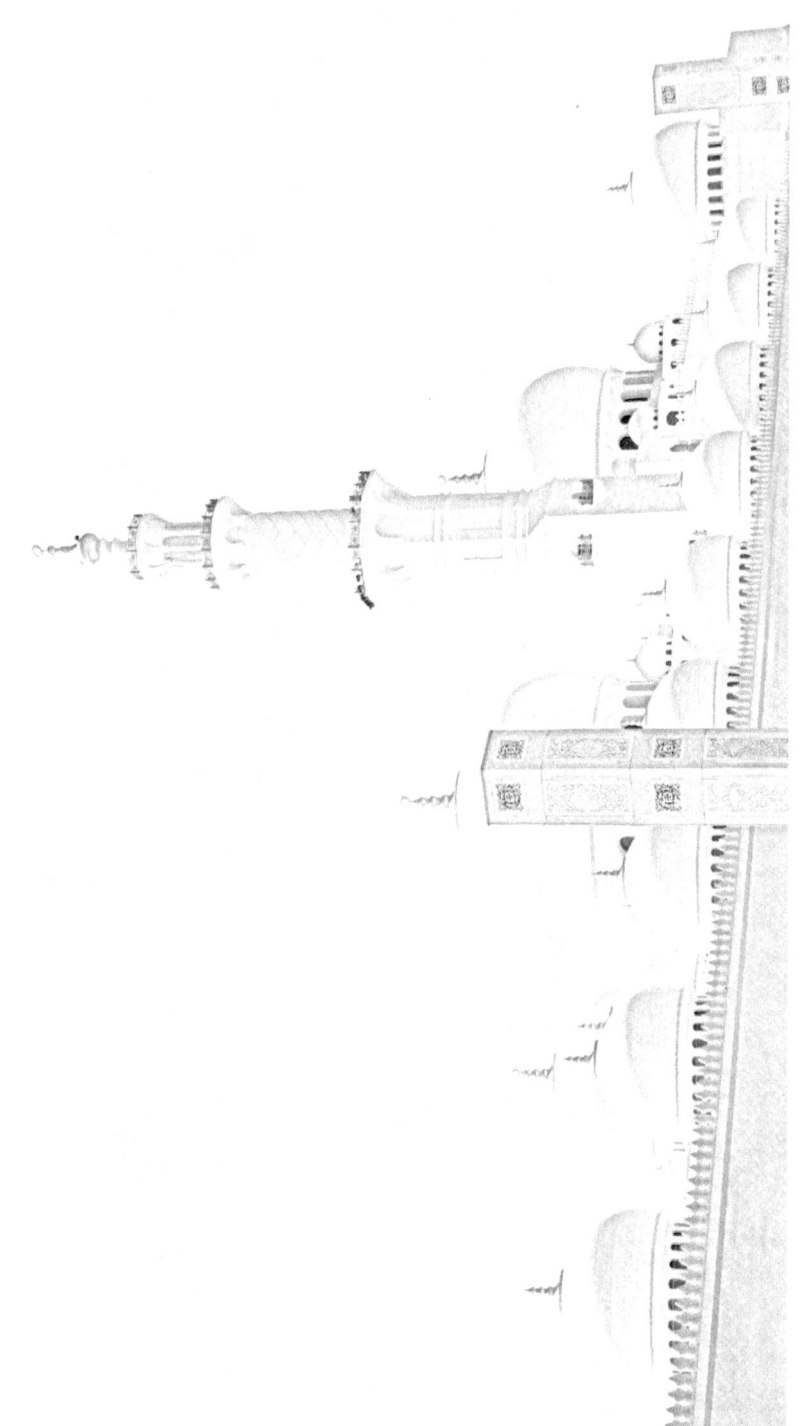

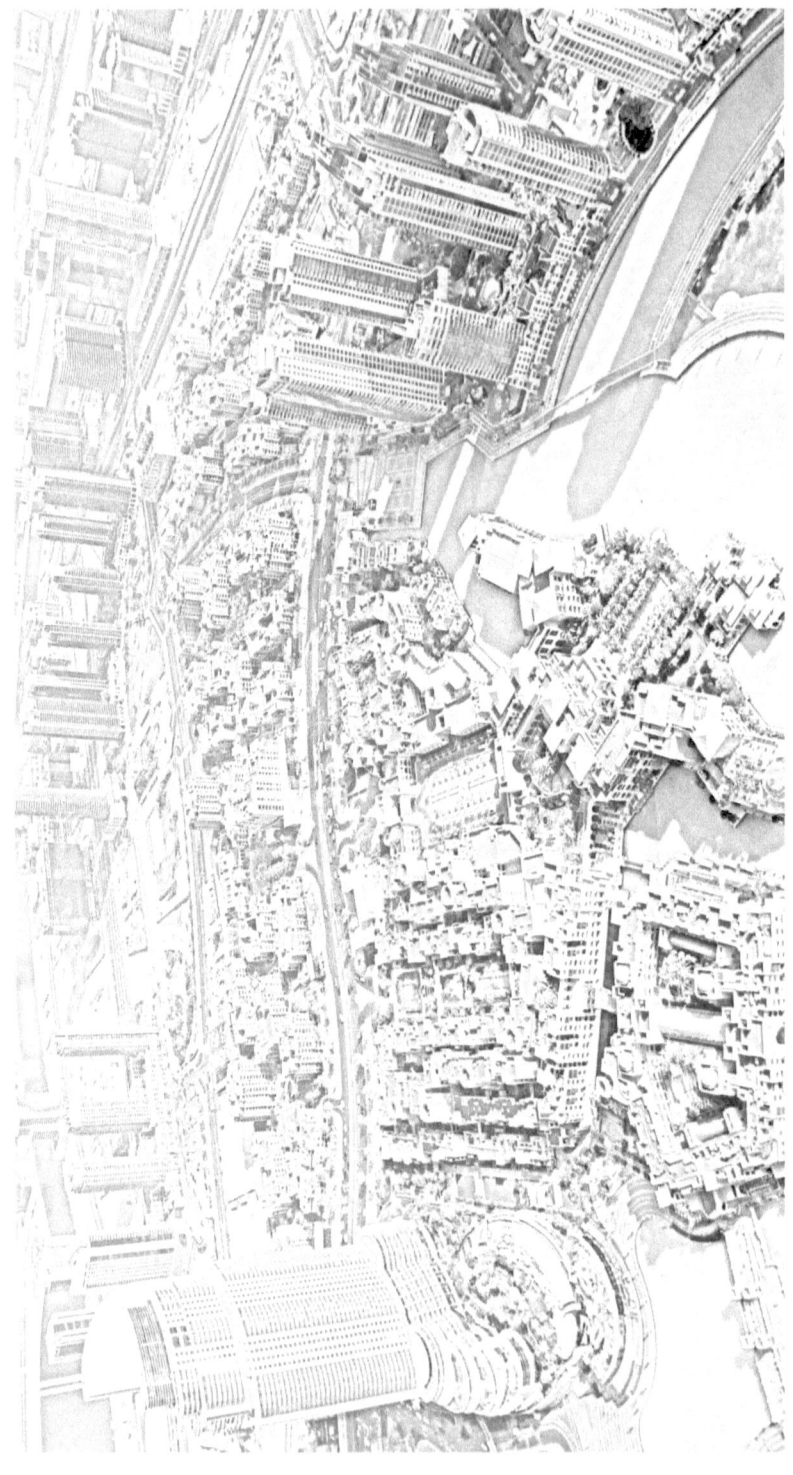

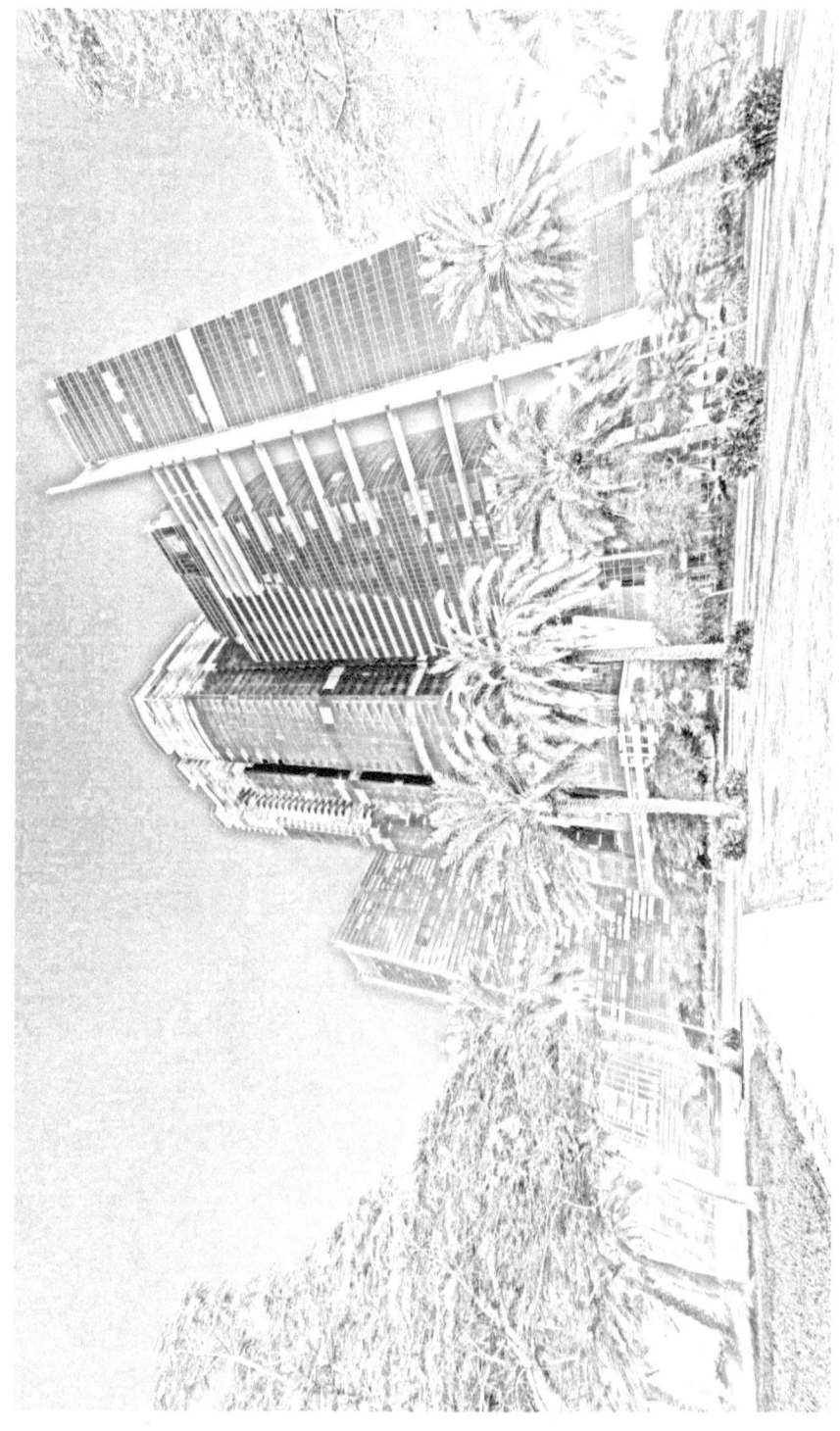

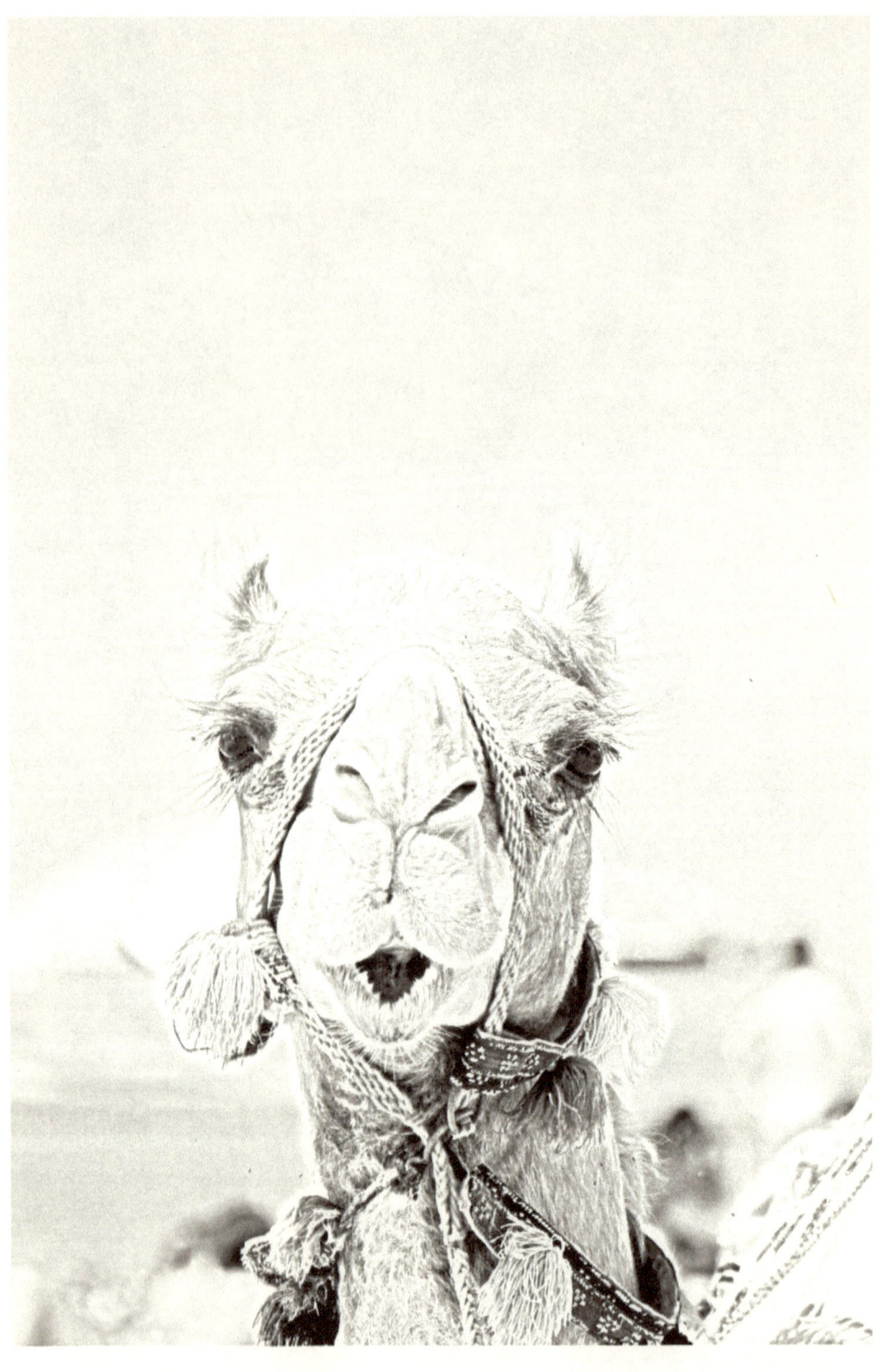

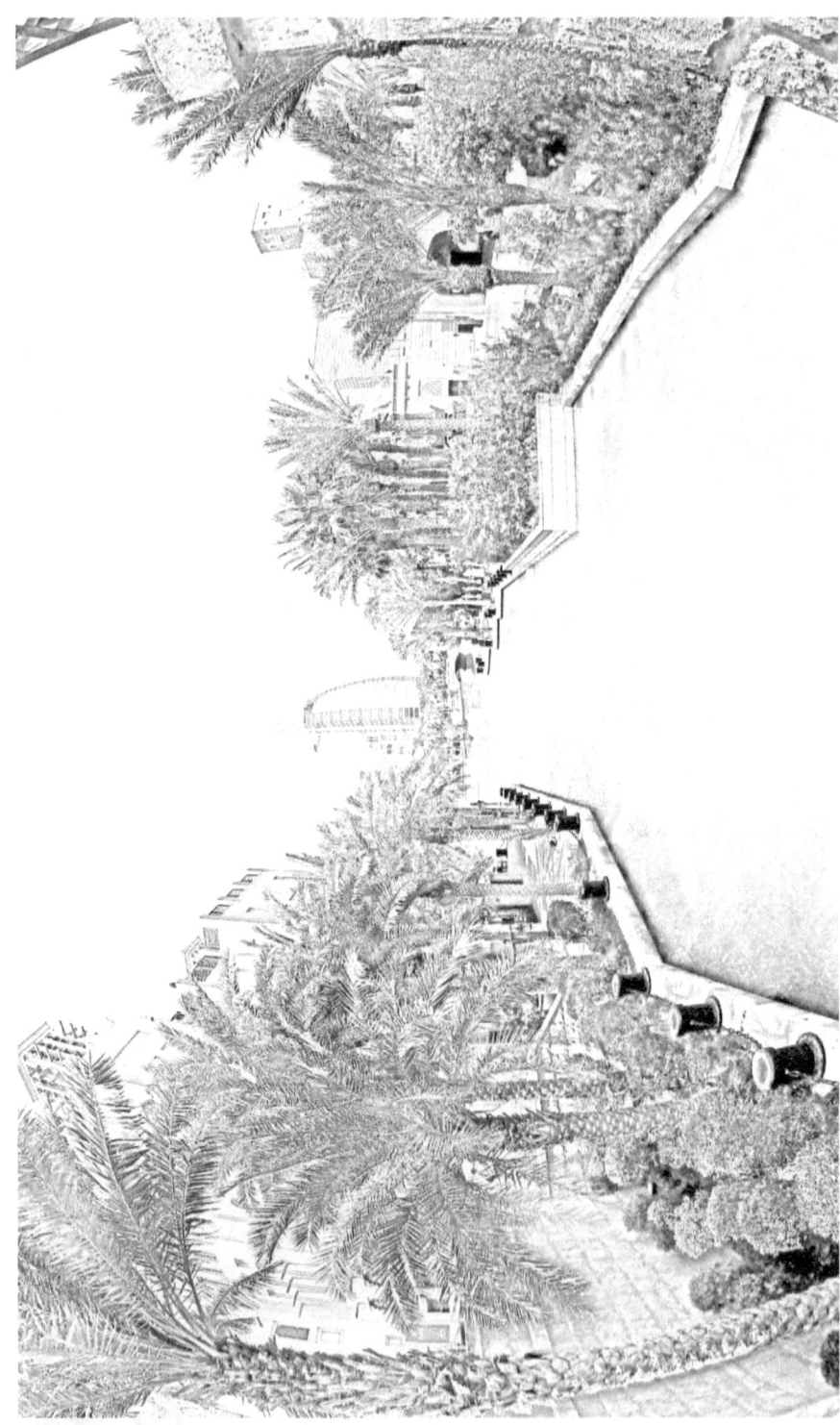

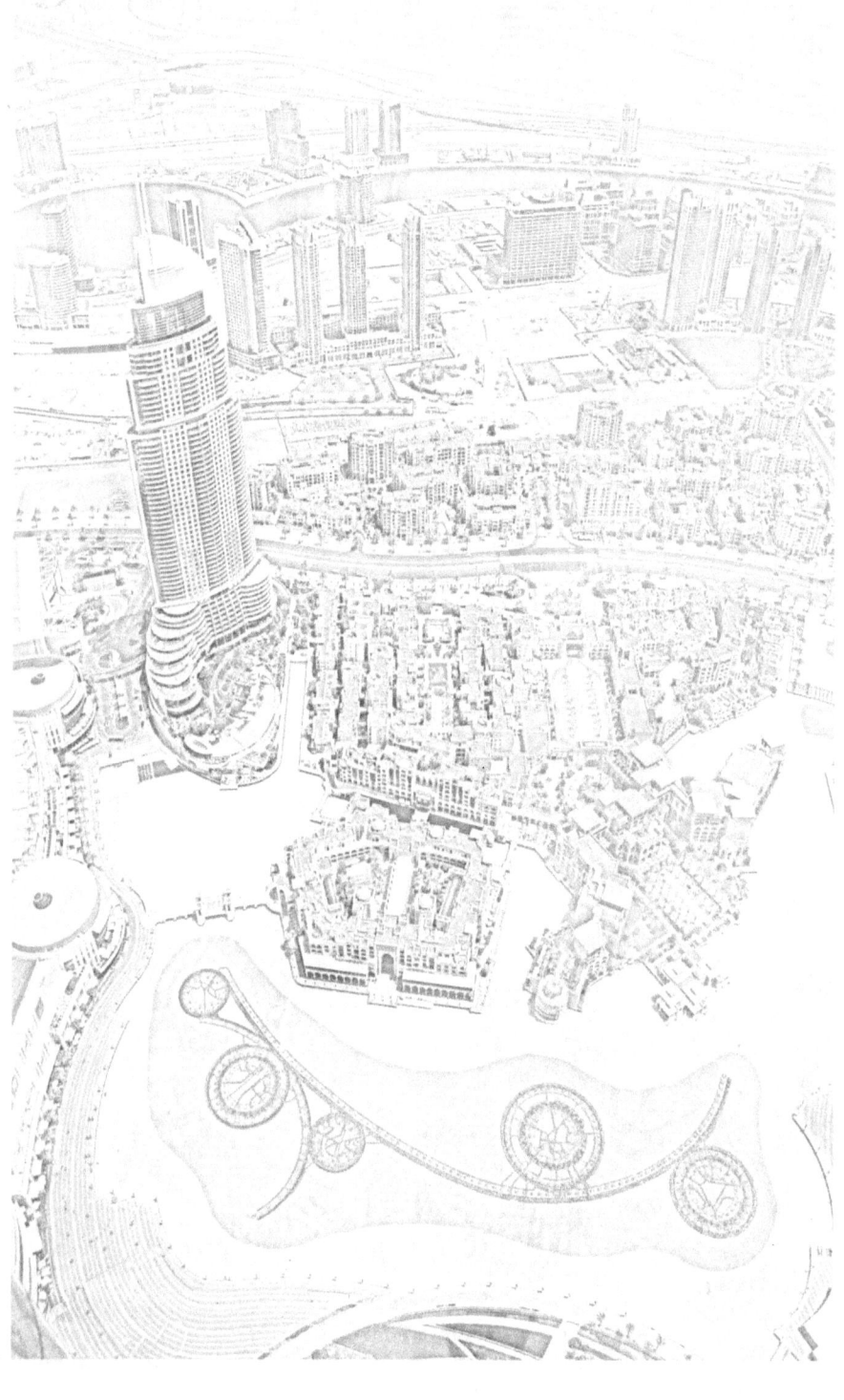

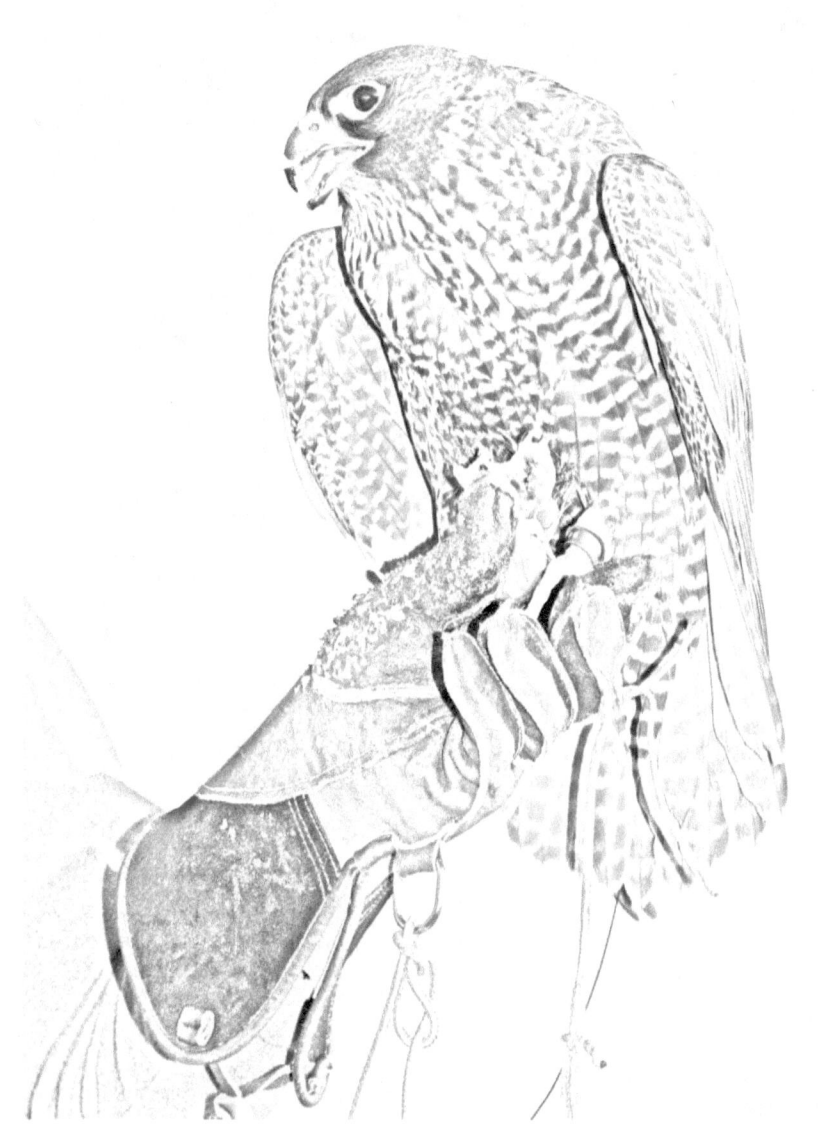

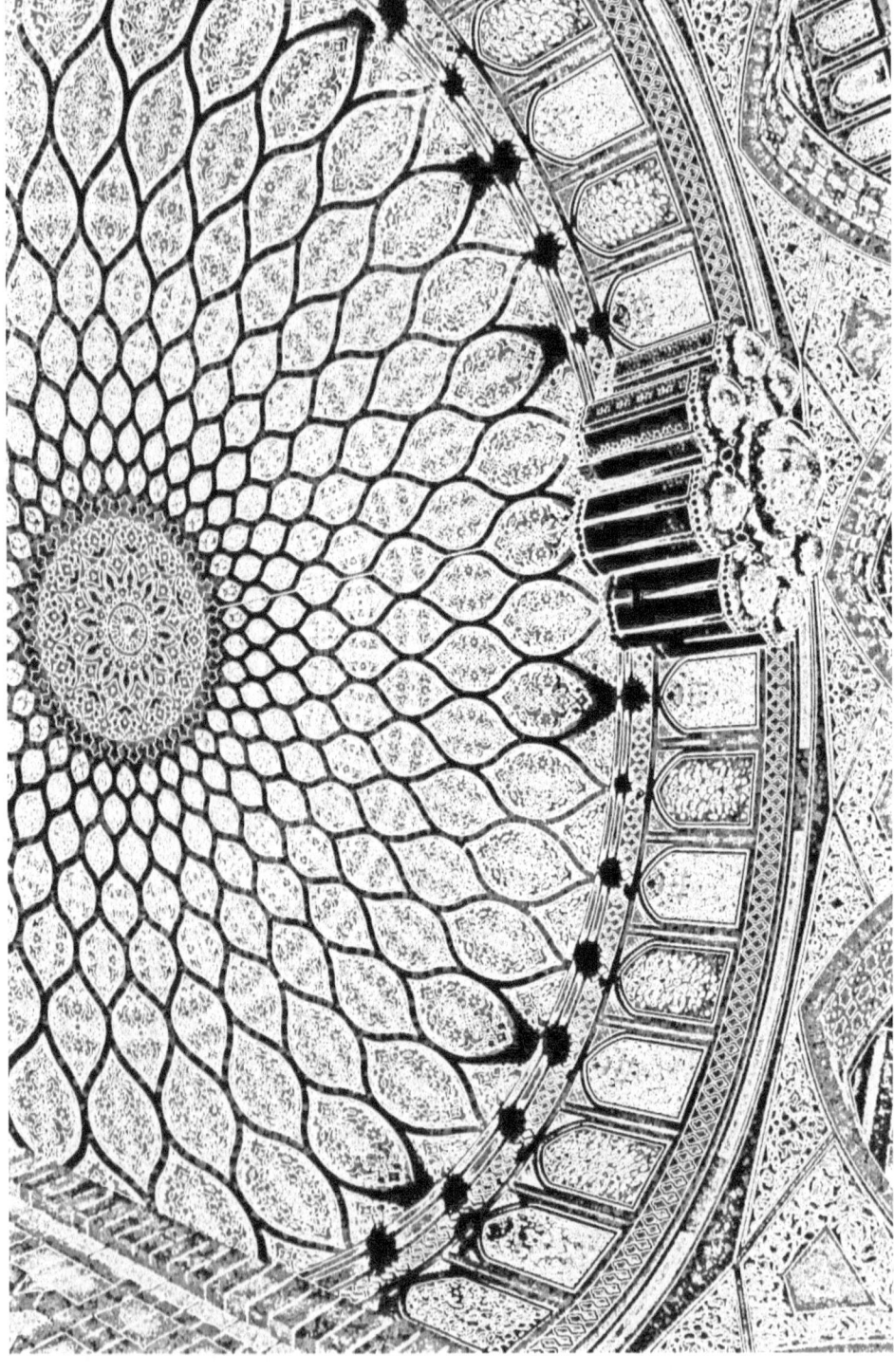

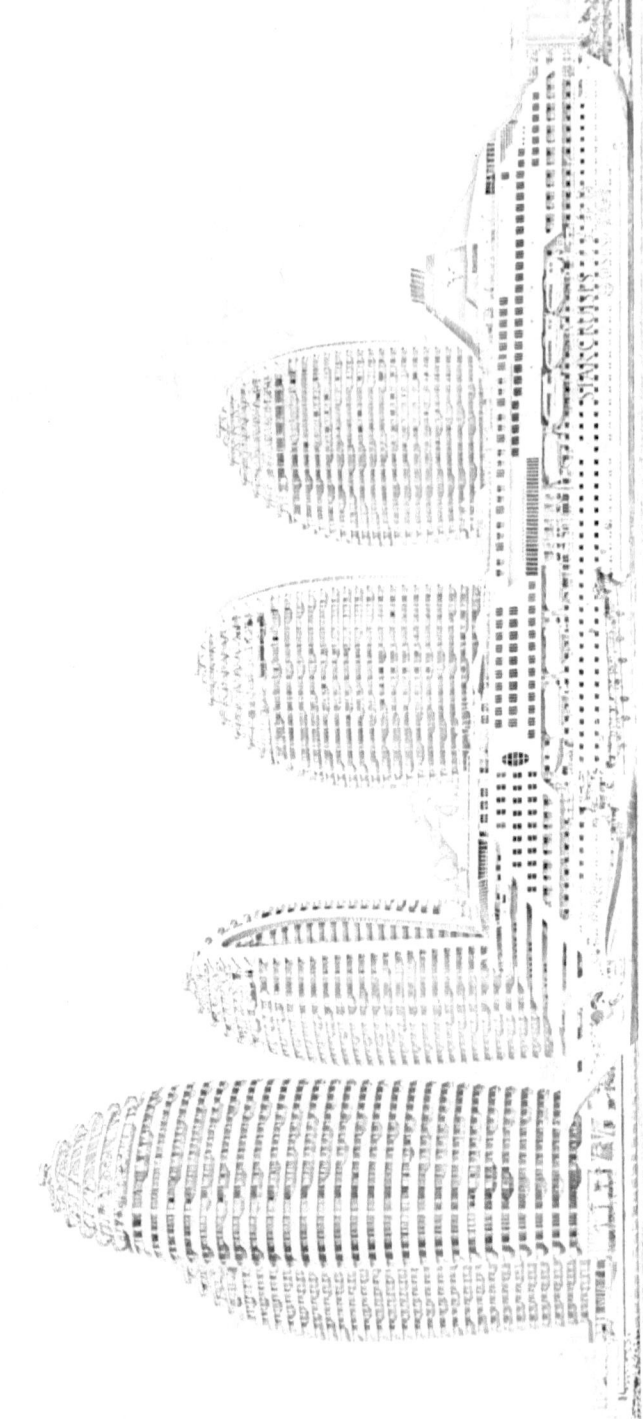

All rights reserved. No part of this publication may be reproduced in any form or by any means, including scanning, photocopying, or otherwise without prior written permission of the copyright holder. Copyright©2017

www.ingramcontent.com/pod-product-compliance
Lightning Source LLC
Chambersburg PA
CBHW021001180526
45163CB00006B/2460